Library of Congress Cataloging-in-Publication Data

Borsari, Andrew.
 Cape Cod National Seashore / photographs by Andrew Borsari ; text by Amy Whorf McGuiggan.
 p. cm. — (New England landmarks series)
 ISBN 1-889833-79-7
 1. Cape Cod National Seashore (Mass.)—Pictorial works. 2. Cape Cod National Seashore
(Mass.)—Description and travel. 3. Cape Cod National Seashore (Mass.)—Quotations,
maxims, etc. I. McGuiggan, Amy Whorf, 1956– II. Title. III. New England landmarks.
 F72.C3B67 2004
 974.4'92'00222—dc22
 2004002852

Cover and interior design by Peter Blaiwas, Vern Associates, Inc.
Printed in South Korea.

Published by Commonwealth Editions
an imprint of Memoirs Unlimited, Inc.
266 Cabot Street, Beverly, Massachusetts 01915
www.commonwealtheditions.com

Images from this book are available from the Borsari Gallery, Tuna Wharf, Rockport, Mass.
(978-546-9683; images@borsarigallery.com) or from the Borsari Studio, Ipswich, Mass. (978-356-0042).

The New England Landmarks Series
Andrew Borsari, Series Editor
Cape Cod National Seashore, photographs by Andrew Borsari
Walden Pond, photographs by Bonnie McGrath

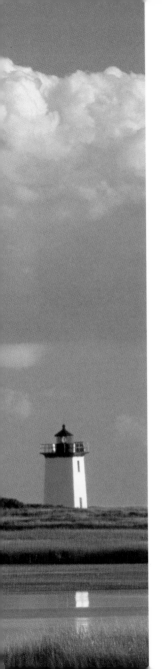

Cape Cod National Seashore

PHOTOGRAPHS BY ANDREW BORSARI

Text by Amy Whorf McGuiggan

COMMONWEALTH EDITIONS
Beverly, Massachusetts

NEW ENGLAND LANDMARKS

Dear Paul

Too bad "the ship" is gone you could take Jigme to see it up close. Remember when you walked out to it!

Love,
Linda

*I*magine a sliver of land that looks like a flexed arm extending out to sea from the southeastern coast of Massachusetts, and you have Cape Cod. Henry David Thoreau described the "bared and bended arm of Massachusetts" this way: "The shoulder is at Buzzard's Bay; the elbow, or crazy-bone, at Cape Mallebarre; the wrist at Truro; and the sandy fist at Provincetown." In concluding his classic book *Cape Cod*, Thoreau noted that "a man may stand there and put all America behind him."

A product of the last ice sheets that receded some 15,000 years ago, the peninsula of Cape Cod is an infant, geologically speaking. Still evolving, ever changing, it is not yet complete. Perhaps it never will be.

You can easily imagine that flexed arm shaking its defiant Provincetown fist at the mighty Atlantic Ocean as if to say, "I won't be taken." But the Cape's precarious place out there in the Atlantic makes it vulnerable to the winds and tides that reshape its intimate nature on a daily basis. What is here today is gone tomorrow. What was not here yesterday is newly arrived today.

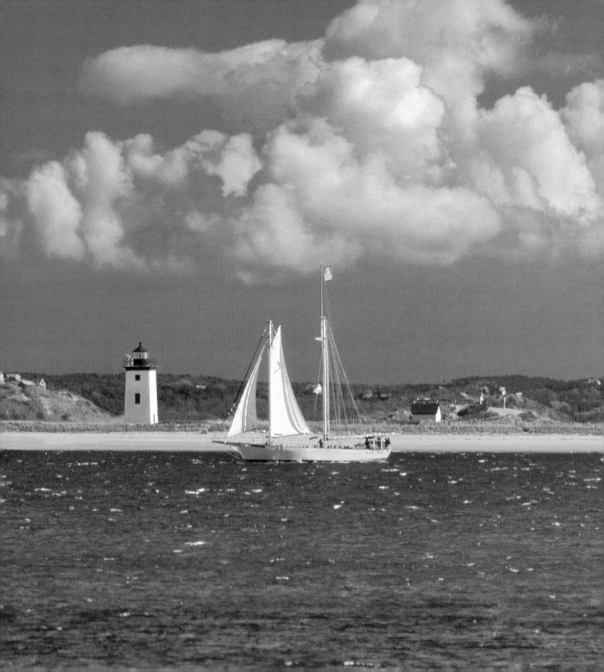

ON THIS SANDY, TILTING PENINSULA SIGHT can keep on going. On one side the head-on majesty of cliffs, beach, and open sea, and on the other, calm low headlands facing sheltered waters, two different environments, with the west wind blowing over and the clouds flaring and shifting in the sky. You are in the lap of the waters, the balance of the tides, and in the arms of the weather.

—John Hay, *The Great Beach*, 1963

Schooner clearing Long Point Light, Provincetown

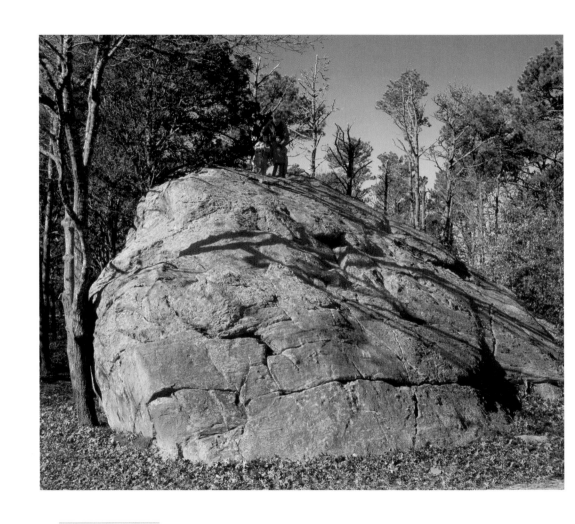

Doane Rock, Eastham

Red Maple Swamp Trail, Eastham *(above)* Nor'easter, Coast Guard Beach, Eastham *(overleaf)*

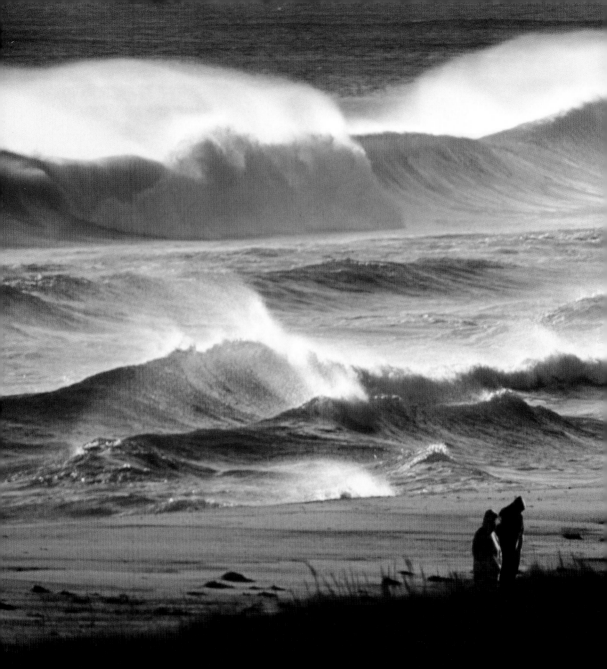

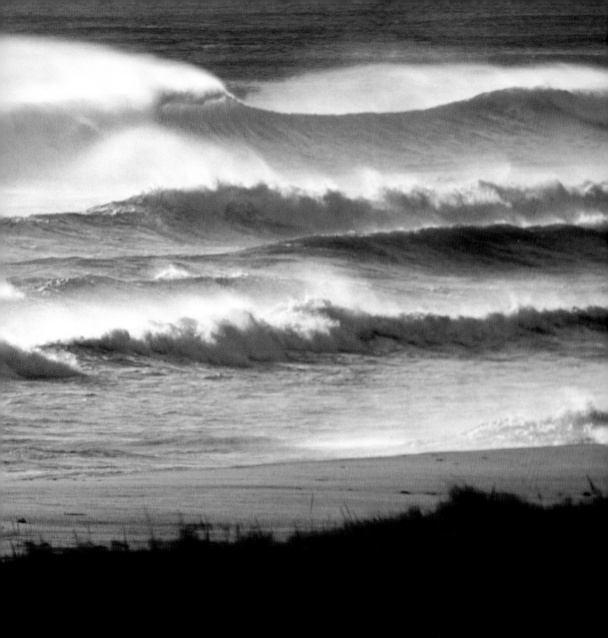

Cape Cod's fragile nature, and her sublime beauty, caught the eye of conservationists and the National Park Service as early as the 1930s. The war years put the ambitions of the Park Service on hold until the early 1950s, when the conservation movement began to gain new momentum. By the mid-1950s, interest was again sparked to preserve—as well as mere mortals could and as Mother Nature would allow—the outer reaches of Cape Cod, to make her shores accessible for the recreation and spiritual pleasure of all.

The proposal to create a Cape Cod National Seashore was not without detractors. Vociferous home-rule voices united to warn of eminent domain takings, to question where boundaries would be drawn, and to worry aloud about the impact such a park would have. Would it harm local economies? Trample traditional freedoms? Interfere with shellfishing and hunting? The ultimate question asked by most everyone was, how *will* the many towns within the park—Provincetown, Truro, Wellfleet, Orleans, Eastham, Chatham—be represented?

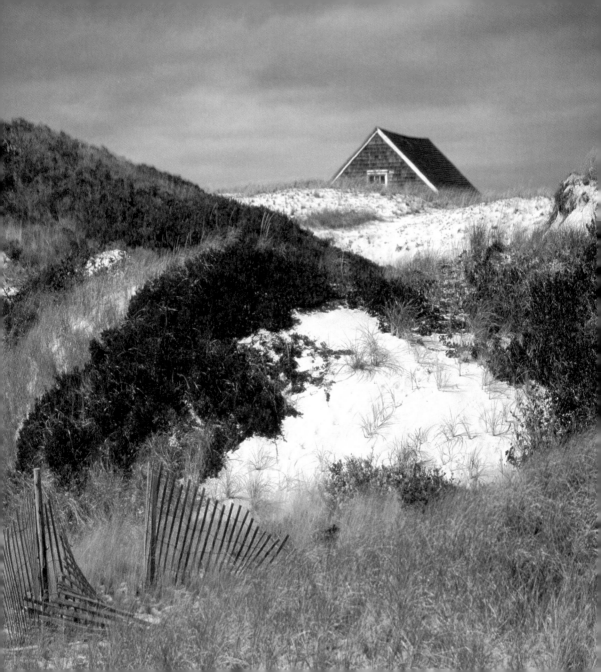

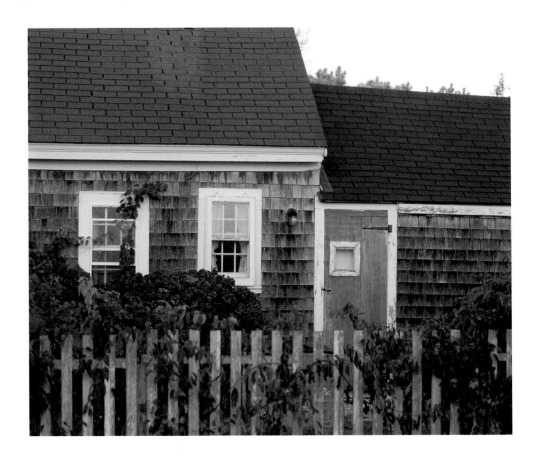

Race Point Beach, North Truro *(opposite)*

"Old Cape Cod," North Truro *(above)*

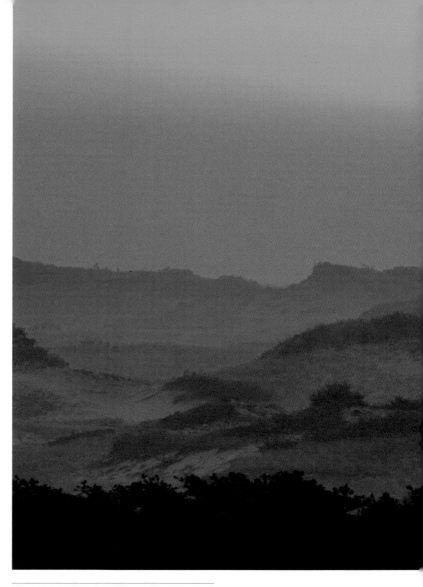

Parabolic Dunes, Race Point, Provincetown

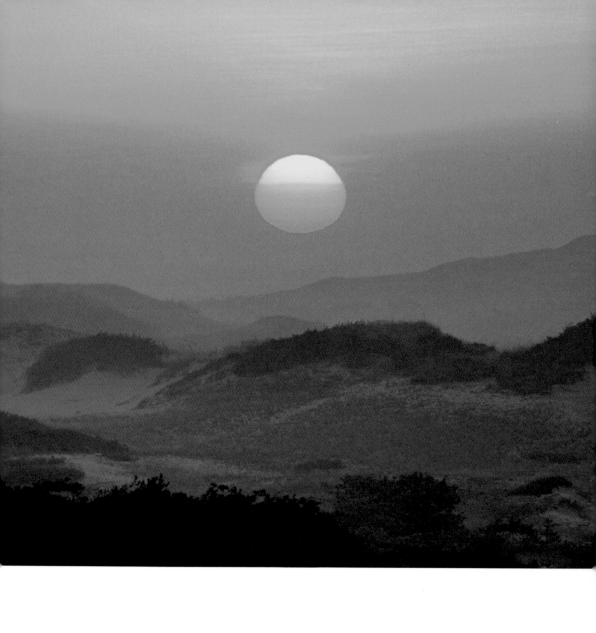

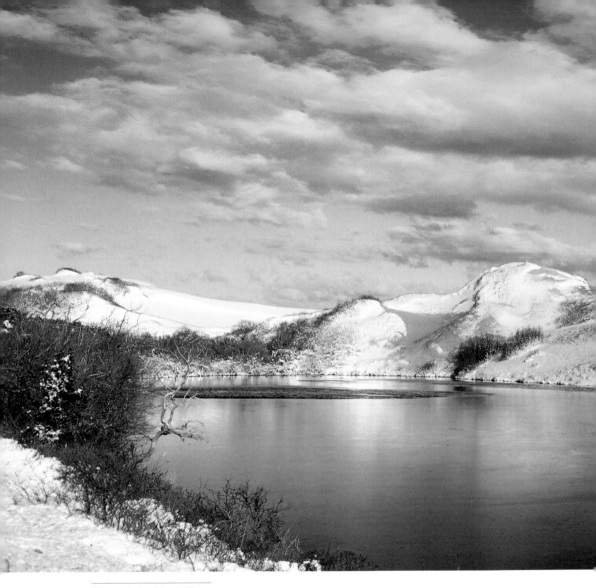

Pilgrim Lake, North Truro

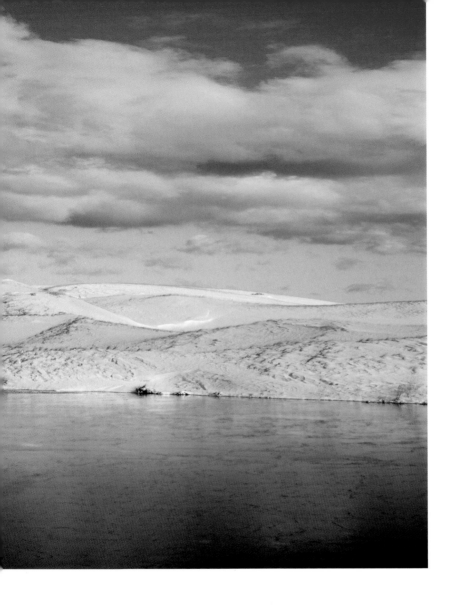

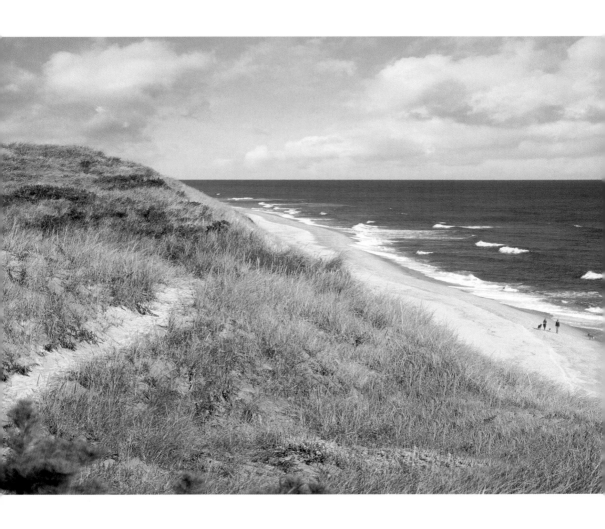

Coast Guard Beach, Wellfleet

I BELIEVE THERE IS SOMETHING ELSE about the beach that comforts and delights us. More than pleasure in the beauty of sand—sand ribbed and patterned by the lapping and pounding of the water, sand covered with the telltale marks of the feet of the birds, or the flurry swept by the tips of their feathers; more even than the pleasure in the ocean itself, there is the awareness of the rhythm of the tides.

—Clare Leighton,
Where Land Meets Sea, 1954

OUR CAPE AIR HAS A POSITIVE ELEMENT
that gives one the effect of tasting or
ingesting something delicious and life-
giving. . . . Call it sparkling, clean, clear,
pure, champagne-like—or what you will;
it has a quality that is indescribable.

—Wyman Richardson,
The House on Nauset Marsh, 1955

Highland Light and Highland Golf Course, Truro

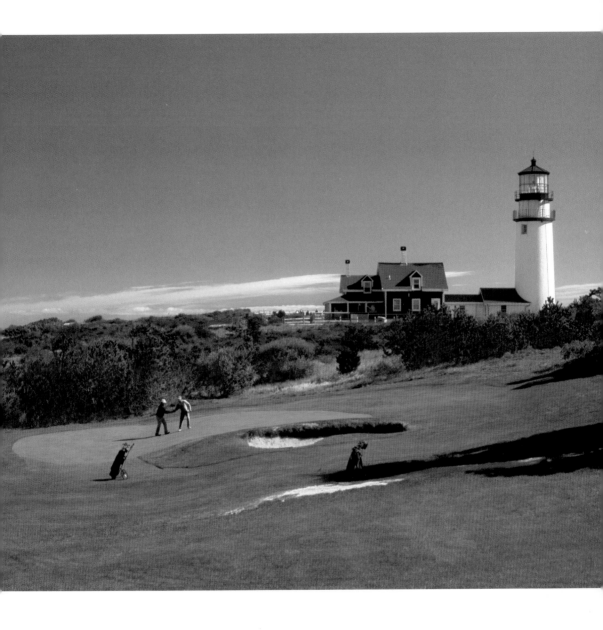

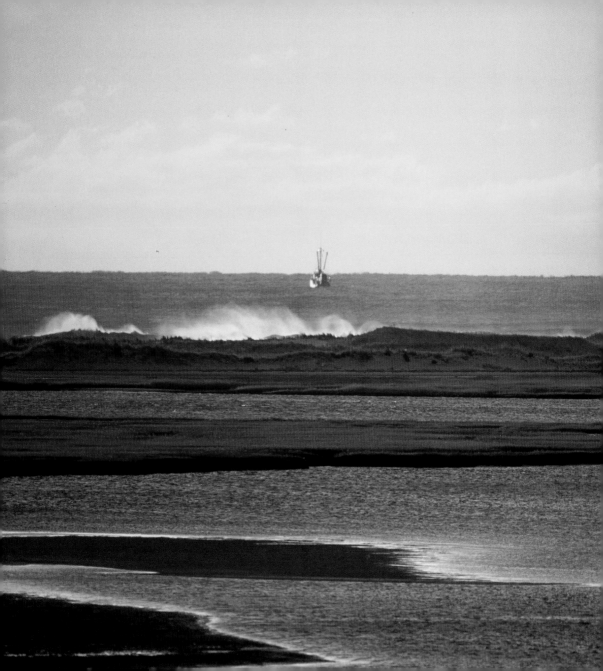

THERE IS SOMETHING MORE REMOTE AND beautiful where the sea meets land than anything else of which one may think. You are caught up in this everlasting exchange of sea and land. For a moment you are living in that rhythm of time where a thousand years are as a day.

—Mary Heaton Vorse, *Time and the Town*, 1942

Fishing boat on high seas from Fort Hill, Eastham

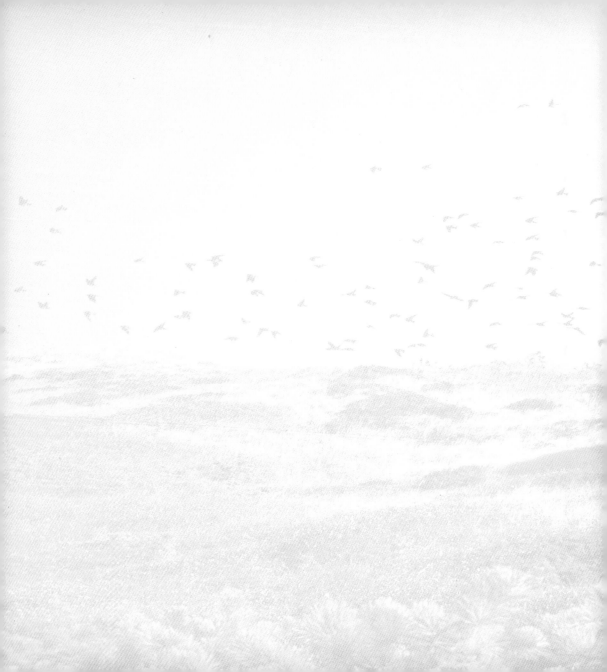

In 1959, the original legislation to establish a Cape Cod National Seashore was introduced in the U.S. Senate by Massachusetts senators Leverett Saltonstall and John F. Kennedy, then a presidential candidate. In the House of Representatives, congressman Hastings Keith, who was said to have the hardest job of "selling" the idea of a national park because the towns involved were his constituency, lent his support to the legislation that would come to be known as the Kennedy–Saltonstall–Keith bill.

It would be another two years before the bill was signed into law. On August 7, 1961, after much deliberation and compromise, revisions, reassurances, and impassioned testimony both for and against, President Kennedy signed the bill creating the Cape Cod National Seashore. Leverett Saltonstall, who was unable to attend the signing, later wrote that the "most sensitive and perhaps the most worthwhile project that John Kennedy and I sponsored was the Cape Cod National Seashore Park." Just days before the signing, the *Berkshire Eagle* opined on its editorial page that the bill establishing the park "can probably be labeled the finest victory ever recorded for the cause of conservation in New England."

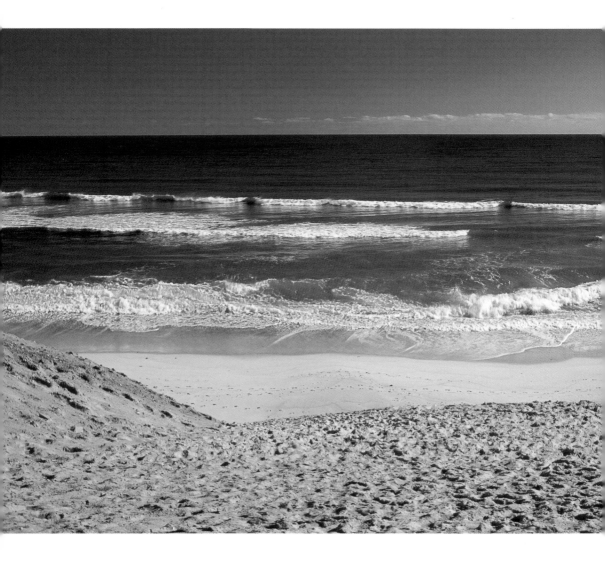

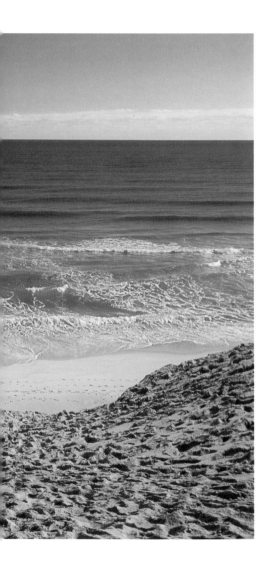

THE SEA HAS MANY VOICES.
Listen to the surf, really lend it
your ears, and you will hear
in it a world of sounds.

—Henry Beston,
The Outermost House, 1928

White Crest Beach, Wellfleet

CLEAN, BRIGHT SPACE, HUGE
sweeps of sand with nothing on
the surface. . . . And it was mine:
there was not a human in sight,
there was no sound. I became a
part of the landscape, like one of
the tufts of beach grass growing
out of the sand.

—Katherine Kellogg Towler,
 "Excerpts from a Journal," in
 From the Peaked Hills, 1988

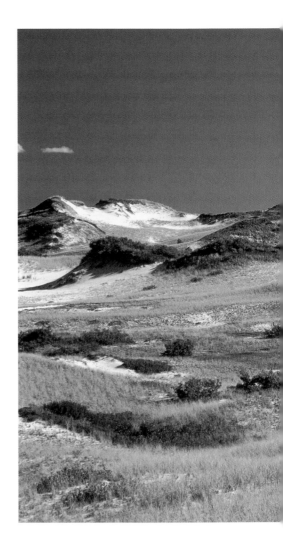

Provinceland dune shack, Provincetown

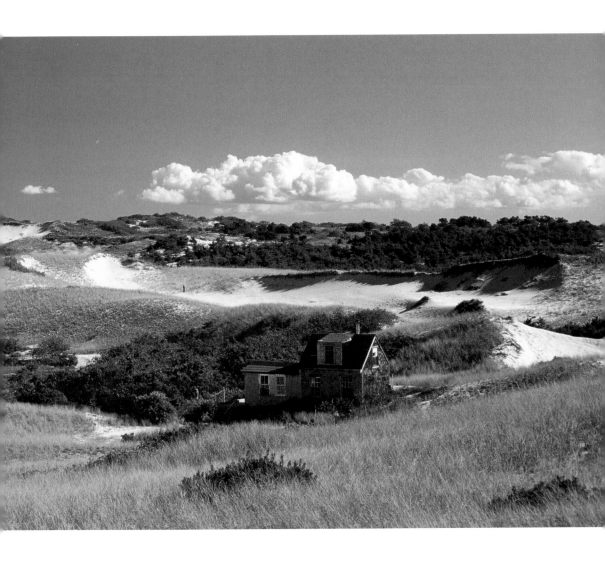

THE PATTERNS OF SEASONAL PERFUMES ARE threaded into the permanent scents of the Cape itself. These are composed of fish and tar, rope, seaweed and salt air, the quality of a clear morning after a northeaster, or the particular smell of low tide.

—Clare Leighton, *Where Land Meets Sea*, 1954

Another fish story, Herring Cove Beach, Provincetown

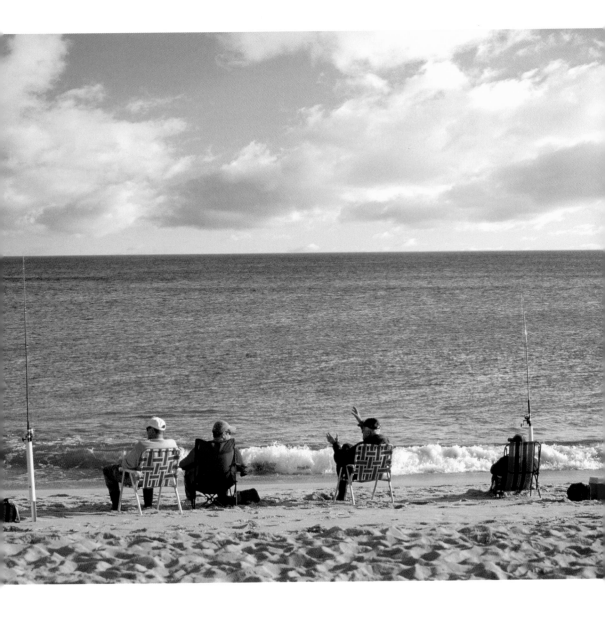

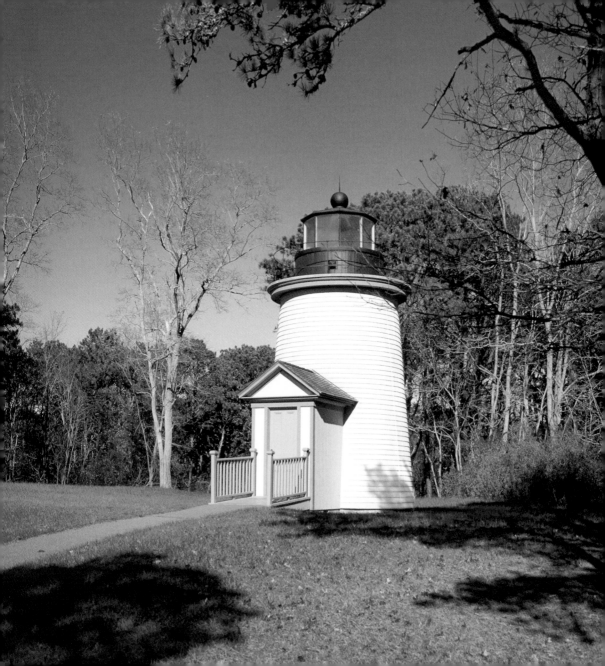

LIGHTHOUSES, FROM EARLIEST TIMES, HAVE FASCINATED and intrigued members of the human race. There is something about a lighted beacon which suggests hope and trust and appeals to the better instincts of all mankind.

—Edward Rowe Snow, *The Lighthouses of New England*, 1945

One of the "Three Sisters," Eastham

THE LIGHT IS CHANGING ALL THE TIME
and land and sea and sky change with it,
and you yourself are changing.

—Katharine Crosby, *Blue-Water Men and*
Other Cape Codders, 1946

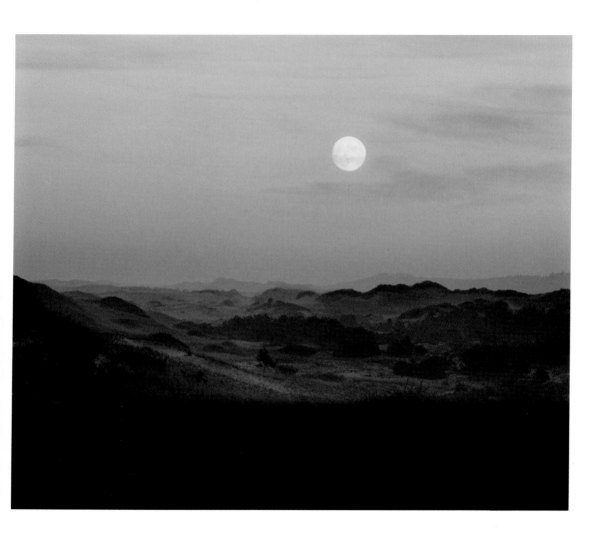

Moonlit dunescape, Race Point, Province Lands

THIS IS THE HARDEST OF ALL SOUNDS in nature to hear: the silent assertion of a landscape itself. It requires a rare confluence of moods—clarity on nature's part, receptiveness on our own—a suspension of normal expectations and a relaxed extension of our senses, to feel such deep vibrations.

—Robert Finch, *Outlands: Journeys to the Outer Edges of Cape Cod*, 1986

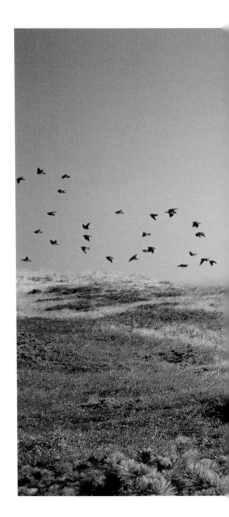

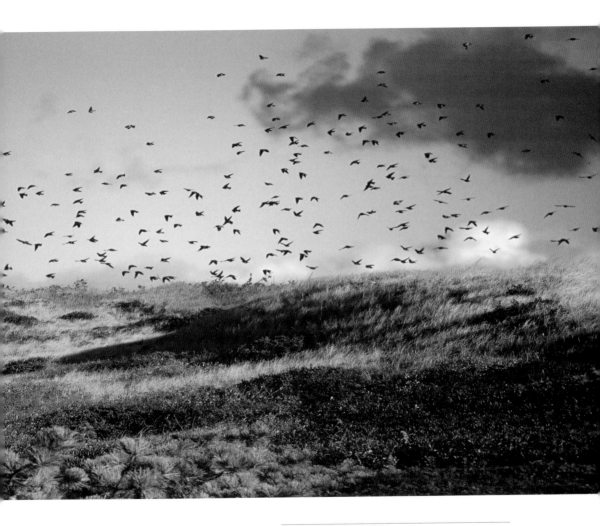

Tree swallows along Ocean View Drive, Wellfleet

Today, more than four decades after a dedicated group of people with a vision, and an eye firmly on the future, dared to believe in a Cape Cod National Seashore, visitors from around the world flock to the 44,000-acre Seashore sanctuary to enjoy its pine woods, sparkling kettle ponds, pungent salt marshes, expansive tidal flats, heathered moors, lonely dunes, safe harbors, ancient byways, quaint villages—and, of course, the magnificent Great Beach about which Thoreau wrote so eloquently.

Within the boundaries of the Seashore are endless opportunities for lodging, dining, and recreation. Forty miles of coastline offer swimmers, windsurfers, and boaters tranquil harbors and coves, as well as temperamental open ocean. The fertile offshore waters make Cape Cod one of New England's premier fishing holes as well as one of the region's trendsetters in whale watching and ecotourism. Biking and hiking trails meander through the woods and dunes. Birdwatchers can focus their binoculars on more than 360 species. Wild cranberry bogs nestle in dune swales, and wildflowers from seaside goldenrod to white water lily to sheep laurel give each corner of the park its own special color and perfume.

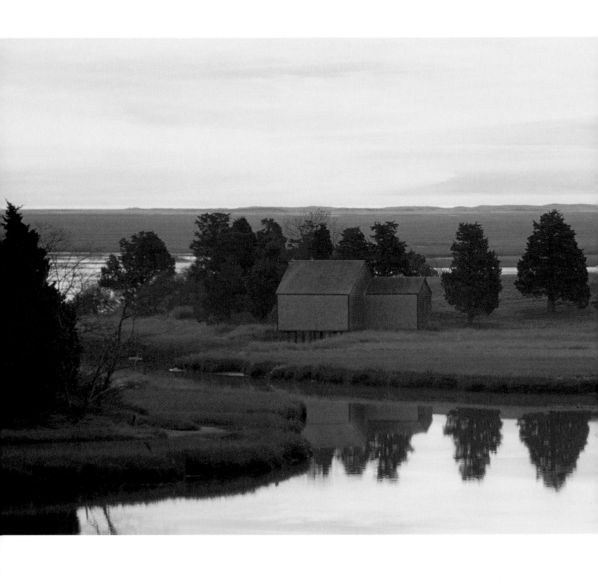

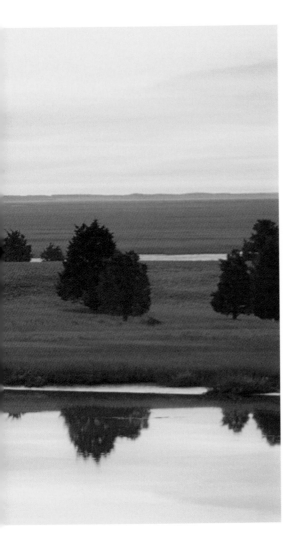

THIS LAND—FAMOUS FOR ITS light—has attracted thousands of artists, but I have yet to find any paintings that match the Cape Cod inside my head. The Cape I love is a Cape of color.

—David Gessner,
 A Wild, Rank Place, 1997

Salt Pond, from the National Seashore
Visitor Center, Eastham

AT FIRST, WITH THE SUN NOT YET DOWN, THE COLORS ARE the usual blue and green and yellow that might be expected. Then it goes, and instantly everything is changed. The world becomes opalescent, translucent, faery. Veils of illusion blur the lines of surf and sea and sand, so that now they sweep away softly into nowhere. The sky turns unimaginable colors and the sea picks them up.

—Katharine Crosby, *Blue-Water Men and Other Cape Codders*, 1946

Mother, child, and camera, Wellfleet

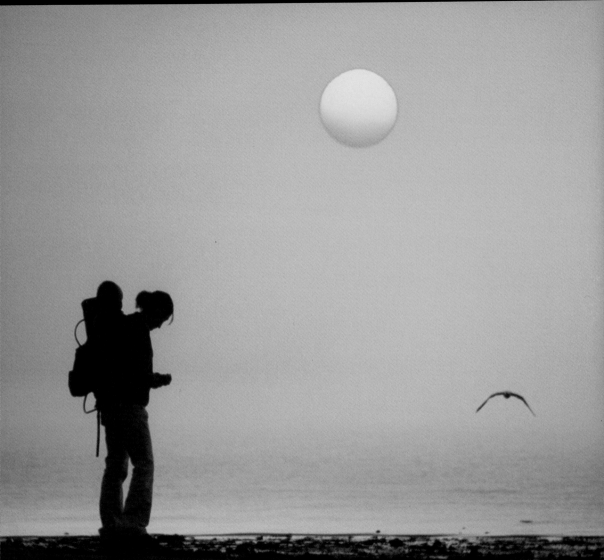

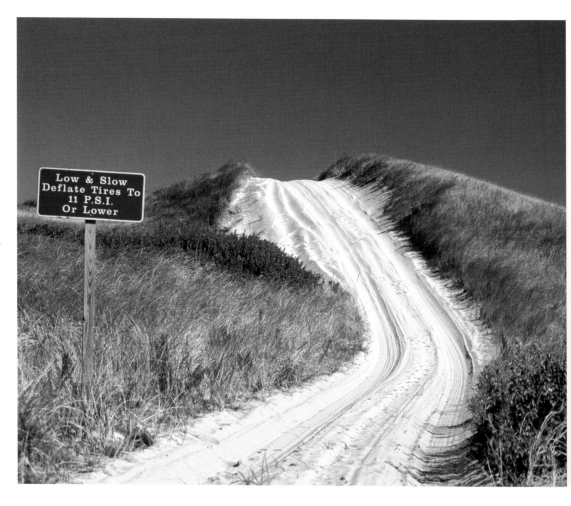

The sign in the image reads:

Low & Slow
Deflate Tires To
11 P.S.I.
Or Lower

I HAVE WANDERED [THE DUNES] THROUGH CHILDHOOD, YOUTH, and age, and have always felt renewed by their strangeness and beauty. They are a zone of magic and poetry, a mysterious backdrop to the town; a wall of silence and tranquility dividing the busy harbor and village from the dark, heaving flanks of the sea. It is as though, on entering on the dunes, one is being led out of this life into another very different, closer to eternal forces.

—Miriam Hapgood DeWitt, "Life on the Dunes,"
 in *From the Peaked Hills*, 1988

Dune trails, Race Point, Province Lands

THE BEACH AWAITS US STILL, AS READY A GUIDE AS EVER
to the secrets of creation, willing as of yore to blow trifles
down the wind. The tide never rises as it rose the day
before, nor ebbs leaving the same burdens in its wake. The
beach is a region as old as time, yet new with the passing
of each hour. It is a benediction and a menace, a healer
and a destroyer, whose nature is the nature of the sea that
made it.

—Henry C. Kittredge, *Mooncussers of Cape Cod*, 1937

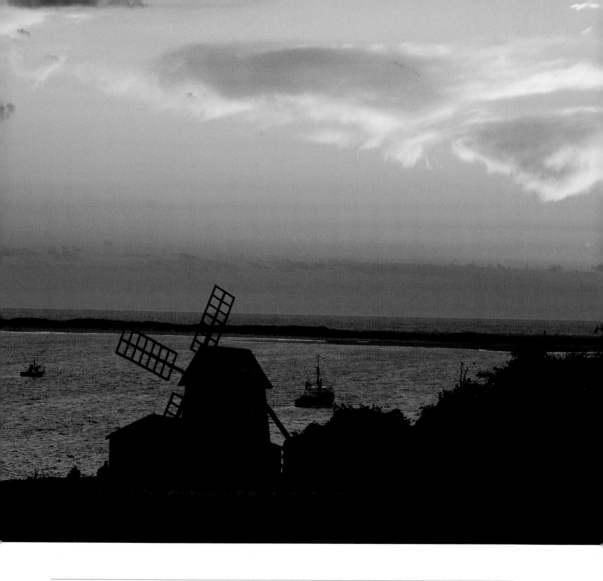

Windmill, between Chatham Bay and Nauset (*above*)

Coast Guard Beach, Truro (*overleaf*)

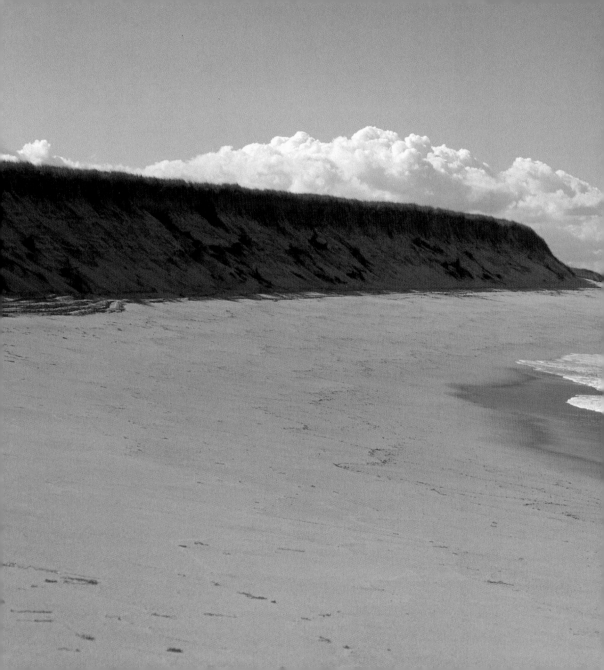

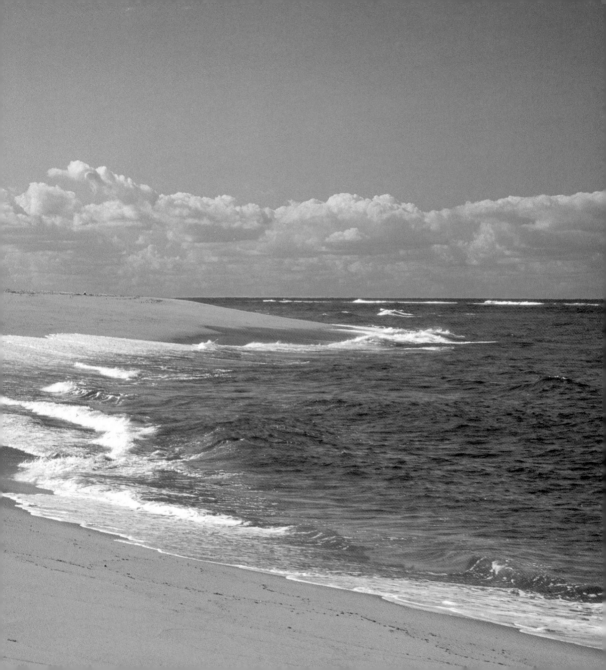

The footprints of man through history have been preserved in the Cape Cod National Seashore. Native American sites and Pilgrim history are part of the park's oral tradition and archeological record. Ranger-guided interpretive walks introduce visitors to the Old Harbor Lifesaving Station, a tangible reminder of the courage of Cape Cod's lifesaving service. Visitors also learn of Captain Edward Penniman, the Eastham man who went to sea for forty years and whose ornate 1868 house with its cupola, mansard roof, and whalebone gateway recalls the heyday of Cape Cod whaling and sea trade. On a windswept bluff facing the Atlantic, the last vestiges of Guglielmo Marconi's wireless station protrude from the sand. It was there, in 1903, that Marconi transmitted the first transatlantic radio message, an exchange between President Theodore Roosevelt and King Edward VII of England. Humble icons are preserved as well, including a 1730s-era Cape Cod dwelling, the simple stalwart lighthouses that served as beacons of hope for seafarers, and colorful fishing boats that have provided a living for generations of Cape Codders.

VIEWED AT EARLY DAWN, WHEN THE FOG FROM THE Atlantic, purpling in the rising sun, bathes the vast sand-drift in a soft amethystine light, the sight is one capable of exciting the deepest admiration.

—Rev. B. F. DeCosta, cited in
 Truro—Cape Cod by Shebnah Rich, 1883

Nauset Beach Light, Eastham

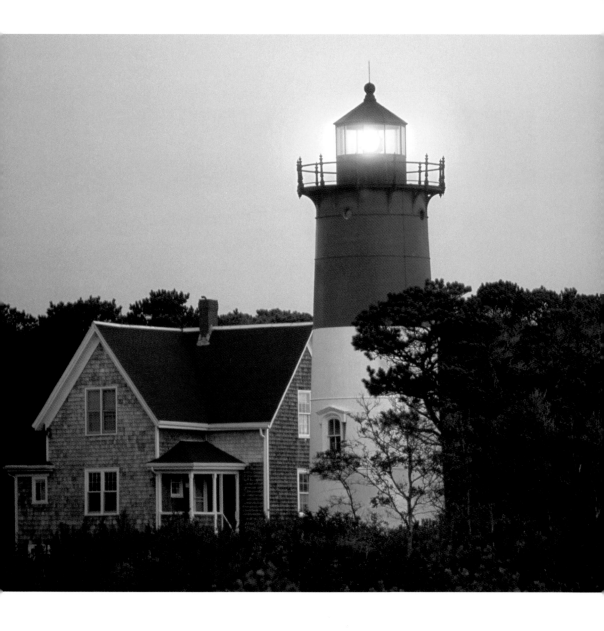

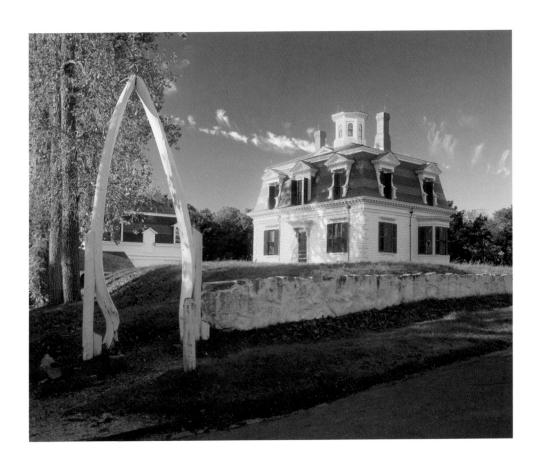

Captain Edward Penniman House, 1868, Eastham

THE SOUND OF THE SURF IS REALLY THE THEME song of the Cape, for you hear it whether you are on Monument Road or Chickadee Lane or Barley Neck or Defiance Lane. Cape Codders need this reassurance that the sea is her own, still unconquered by man.

—Gladys Taber, *My Own Cape Cod*, 1971

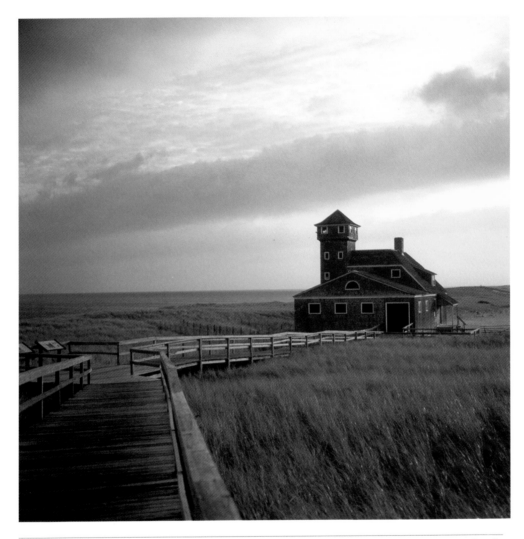

Old Harbor Life-Saving Station,
Race Point, Provincetown (*above*)

The way to Marconi Beach,
Wellfleet (*opposite*)

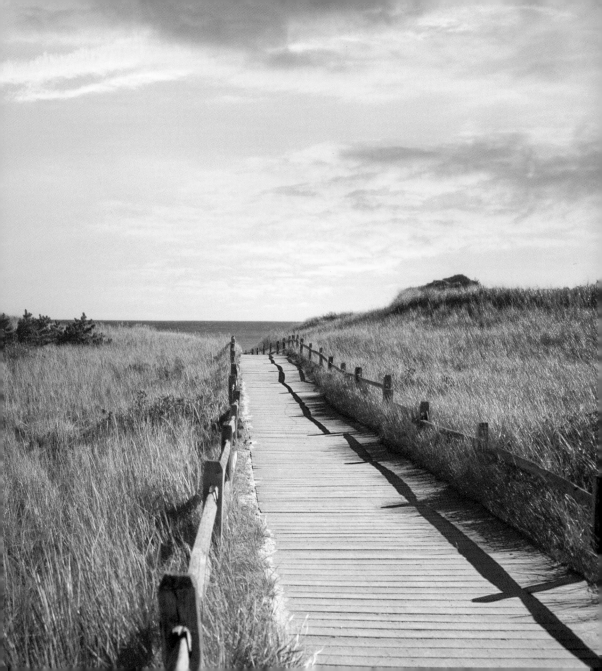

ALL POPULATIONS HERE, HUMAN AND OTHERWISE, change with the seasons. There is a strength to this place that cannot be owned, but only inhabited.

—Cynthia Huntington, *The Salt House*, 1999

Atwood Higgins House, Wellfleet (*opposite*)

Coast Guard Station, Eastham, across Nauset Marsh (*overleaf*)

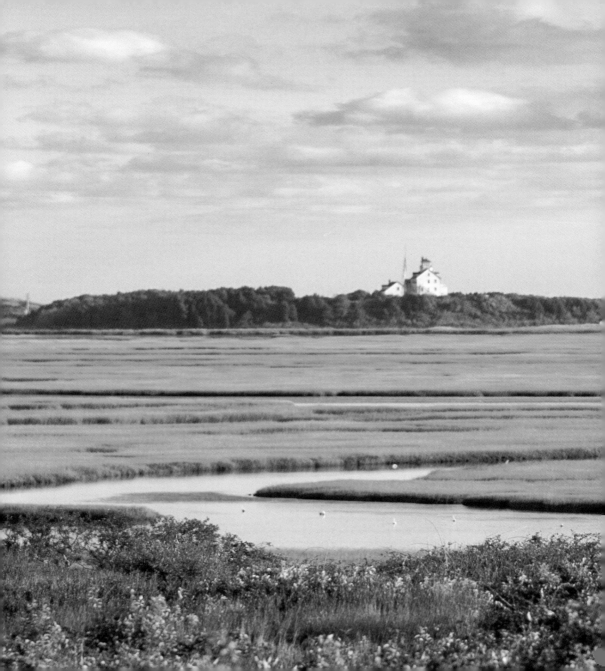

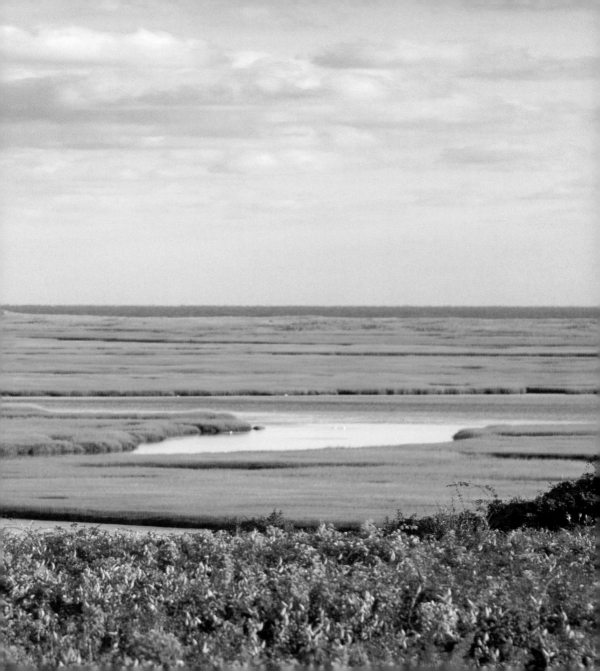

Thoreau himself could not have imagined how fashionable Cape Cod would one day become, though he did write, a century before the Cape Cod National Seashore was created, that "the time must come when this coast will be a place of resort for those New-Englanders who really wish to visit the sea-side."

How could that tenacious citizenry have anticipated, half a century ago, the encroachment of modern life on Cape Cod? How could they have known that Cape Cod would, indeed, blossom into a place of resort, into one of the country's premier summer playgrounds and sandboxes? How could they have known that postwar sprawl might quickly threaten to interrupt Thoreau's "vastness" and overtake Cape Cod the way it has in so

many other places? While political clout and thoughtful legislation saved the physical landscape, those of us who love Cape Cod understand that something less tangible, but far more precious, was also saved.

In a statement before a Senate subcommittee, Leverett Saltonstall noted with prescience, "We cannot advocate 'preservation' in a vacuum. We hope to keep the Cape largely the way it is in order that the people who live there now can continue to enjoy it and so that other Americans, in dire need of the natural grandeur of the clean, open spaces, will find an outlet from their crowded, grimy, urban lives. 'Recreation' merely enables people to share the park's refreshing beauty. This dedication to the spiritual replenishment of modern man is the essence of the whole concept of a park on the Cape."

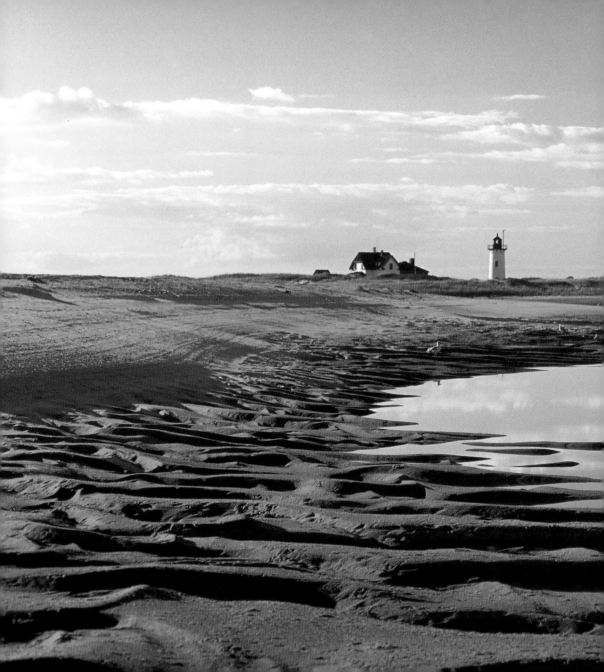

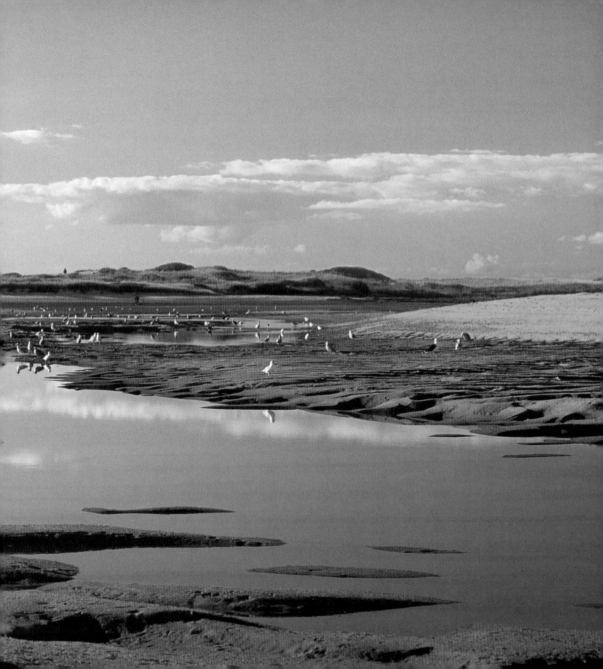

I THOUGHT AS I LAY THERE, HALF AWAKE AND HALF ASLEEP, looking upward through the window at the lights above my head, how many sleepless eyes from far out on the Ocean stream— mariners of all nations spinning their yarns through the various watches of the night—were directed toward my couch.

—Henry David Thoreau, about his stay
 at Highland Light, *Cape Cod*, 1890

Hatches Harbor, Provincetown (*overleaf*) Highland Light (Cape Cod Light), Truro

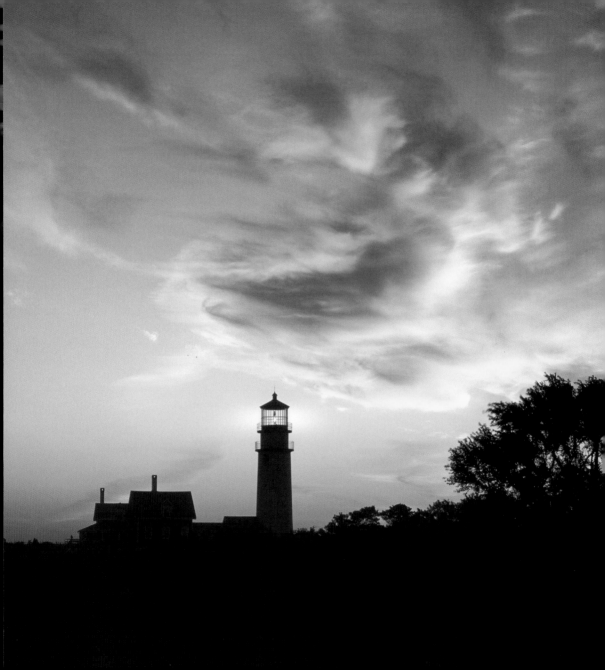

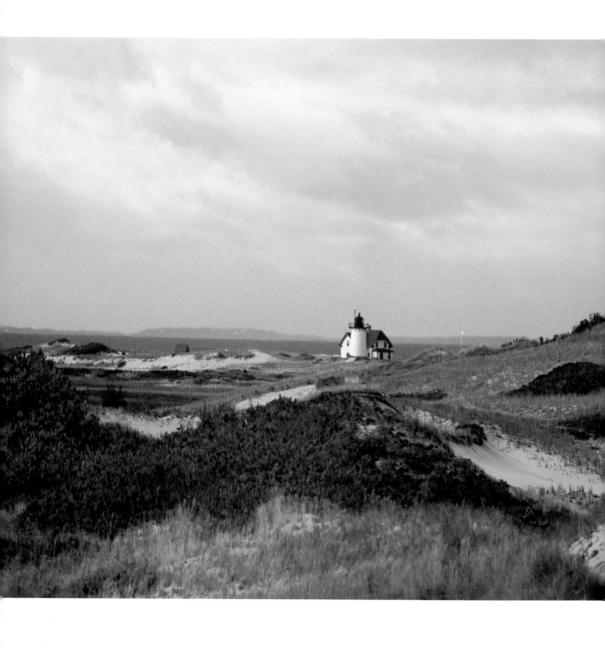

THE DUNES ARE A LANDSCAPE
whose music is ethereal—a gentle
sibilant wind, a rustle of leaves,
sweet, flutelike odes from a rook-
ery—a counterpoint to the thun-
dering percussion of the ocean.

—Amy Whorf McGuiggan,
My Provincetown, 2003

Race Point Light, Provincetown

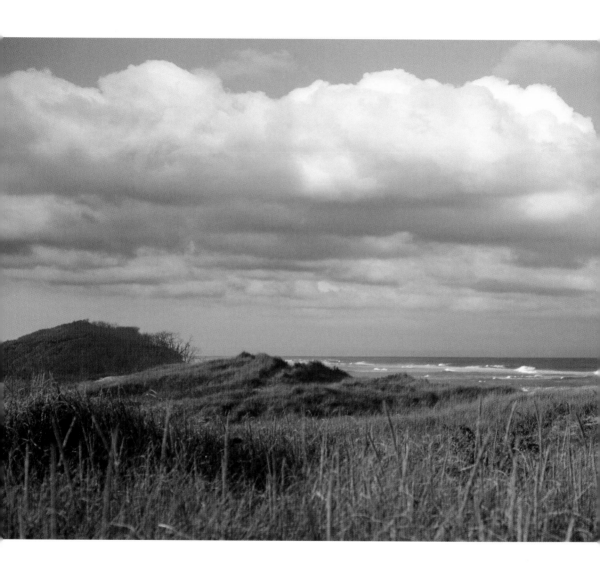

ALL OF US ARE DRAWN
to the sea's edge as to a
fire. Its vast reaches roll
and heave in the light.
There is an incalculable
weight of waters with-
held just beyond us, a
roaming kept in check.

—John Hay,
 The Great Beach, 1963

Head of the Meadow Beach, Truro

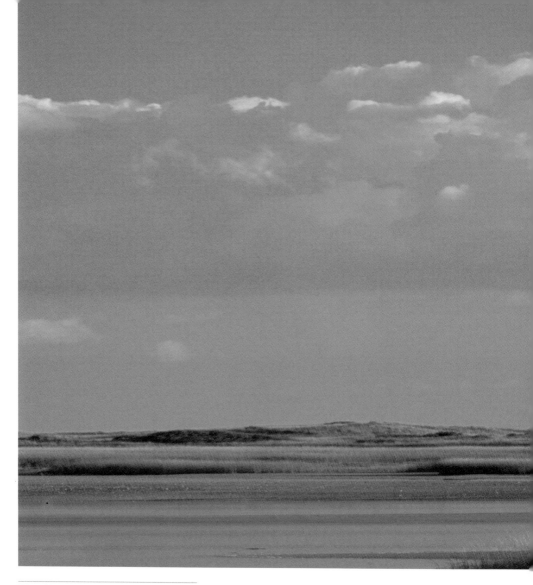

Wood End Light, Provincetown (*above*)

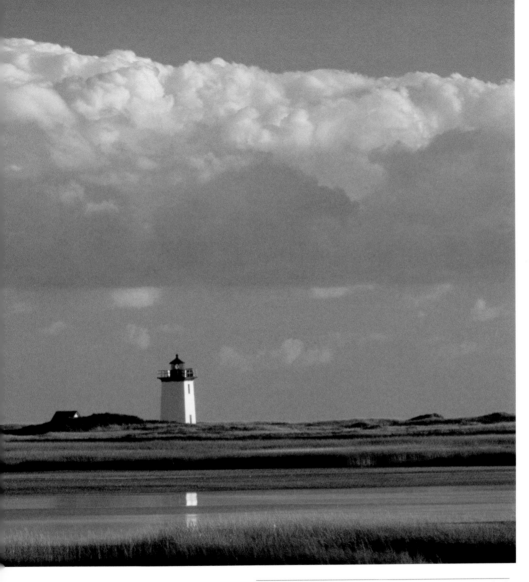

Atlantic sunrise, White Crest Beach, Wellfleet (*overleaf*)

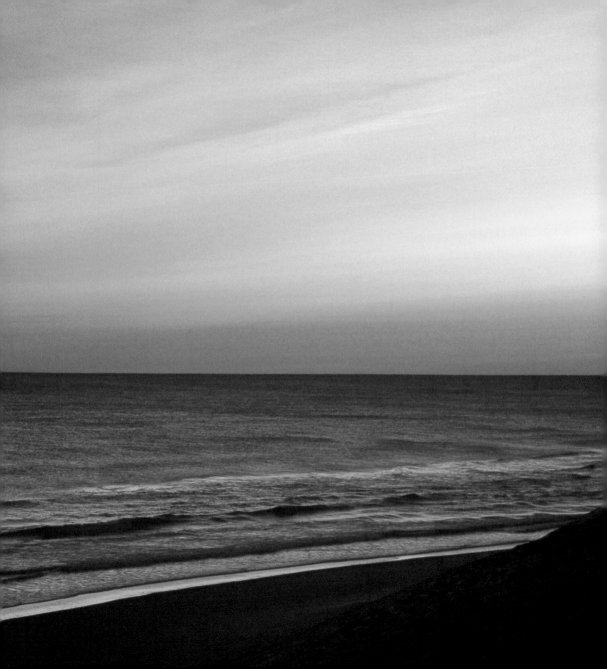

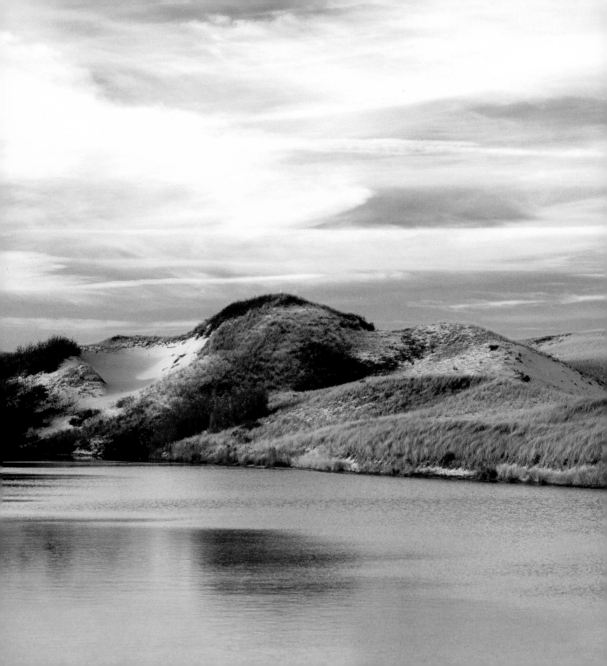

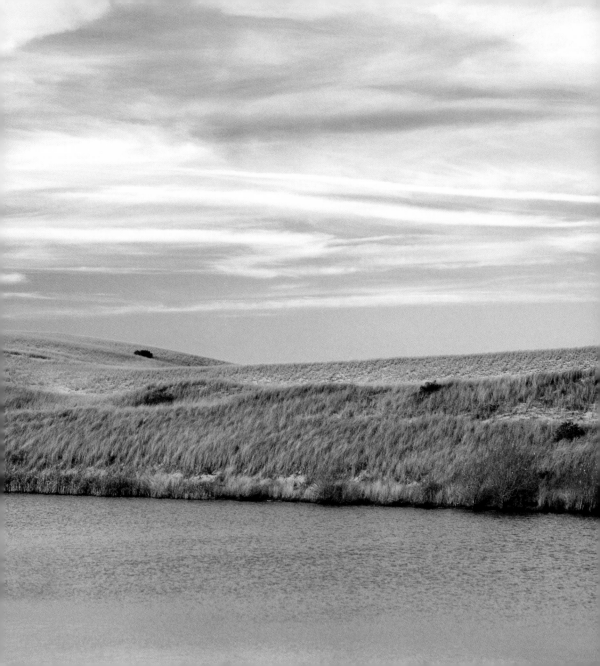

A MAN MAY STAND THERE

and put all America

behind him.

—Henry David Thoreau,

Cape Cod, 1890

Pilgrim Lake, Truro (*overleaf*)

Cahoon Hollow Beach, Wellfleet (*opposite*)

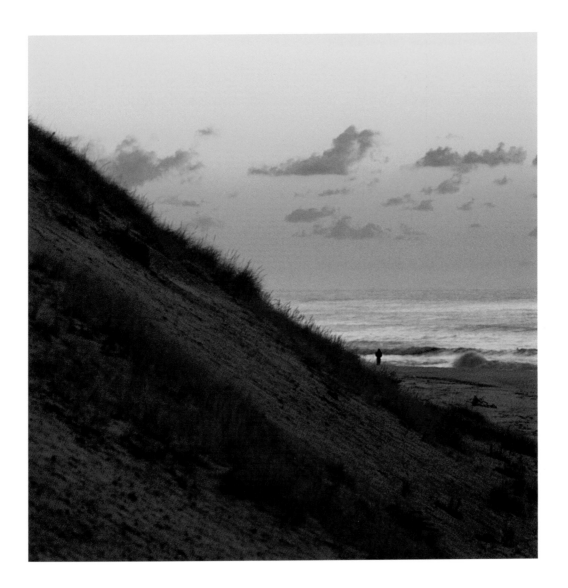

ACKNOWLEDGMENTS

I am grateful to Webster Bull, my publisher, who has broadened my horizon with yet another challenge. Thanks also to Russell Scahill, who has offered creative assistance in my studio; to Amy Whorf McGuiggan, who wrote the text for this book and also chose the quotations; to Peter Blaiwas of Vern Associates, who developed the design for the New England Landmarks series; and to Penny Stratton, who worked with everyone to bring this book to print.

Finally, many thanks are also due to Charles and Gail of Fields Gallery in Provincetown on Cape Cod.

Photo By Skip Kaminsky

Andrew Borsari is a native New Englander and has been actively involved in photography for over forty years. His work has been featured on the television series *Chronicle* and magazines such as *Shutterbug* and *Outdoor Photographer*. In addition, UNICEF International and Image Resource International have printed his images on greeting cards and posters. The author of *Ipswich: A Celebration of Light, Land, and Sea*, Borsari lives in Ipswich, Massachusetts, where he maintains a studio, and operates the Borsari Gallery in Rockport, Massachusetts.

Amy Whorf McGuiggan is the author of *My Provincetown: Memories of a Cape Cod Childhood*. She lives in Hingham, Massachusetts.

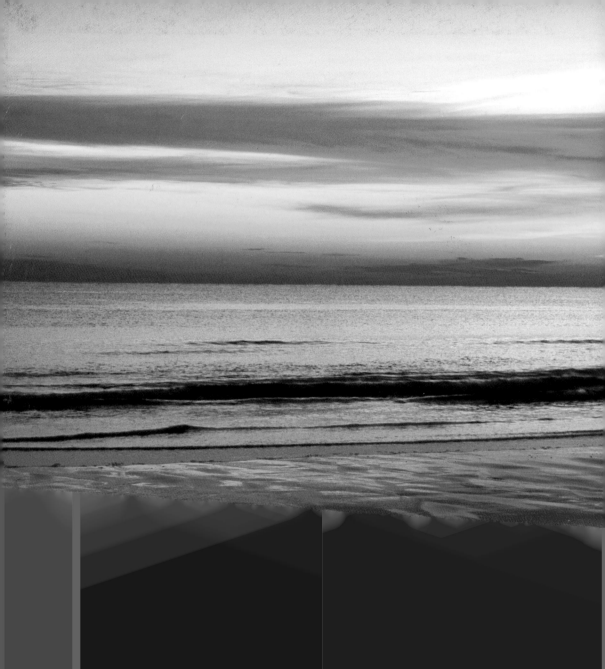